If you like
DEN'S DOODLES 2fers
you'll like this one too!

Also from

THERE'S A BUG GOING AROUND.

"HI! HOW'S IT GOIN'?"

"HEY JERRY! LONG TIME NO SEE!"

"BUTCH! HEY BUTCH! WHAT'S UP, GUY?!"

The Herndurns were relieved to know that it wasn't a wasp nest after all. Just some old growth or something.

The Burfo gang slowly pull into town.

DHARMS ENJOYS "PET-DA-BUTT" TAG. RAYO DOES NOT.

BARON MANOR WAS BARREN OF MANNERS.

BURRRUP.

JIMMY'S FLYING DREAM TAKES A WRONG TURN.

NOT GOOD. NOT A GOOD THING AT ALL...

SABRINA GINA TINA LIKED TO EAT GREEN BANKS FROM ARIZONA.

ISAAC ACTUALLY DID FIND A REAL VARMIT FROM VARMITIA THIS TIME.

BACK IN HIGH SCHOOL EVERYBODY WANTED TO BE THEM.

CHIC ENJOYS AN AFTERNOON ON THE ANDYS.

EVERY DAY, JUST AROUND 4:00, EDWARD FIRDS GIVES THE OLD FACE A GRINNING WORKOUT.

FRANK AT THE BEACH.

VALTADURD SEES THE NEED FOR A SPEED BUMP.

Duck...Duck...Duck... GOOSE!!!

There it stood...silently beckoning Joan... the mysterious entrance to Greaseland.

Rufus Ztupei's Doofus Pupets Bigbutt Strut.

Mayon was tired of folks sticking their noses into his business.

IT WAS ONE OF THOSE MOMENTS WHEN FRIENDS TRULY ENJOY EACH OTHER.

ALLEN'S HOUSE-PLANT WAS NOT HOUSE-BROKEN.

A LITTLE BIRD DIDN'T TELL JORGE ANYTHING...

IT WAS A SLIGHTLY LARGER ONE NAMED ROGER WHO JUST KEPT YAPPING AWAY JOYFULLY.

JOEY LIKES TO PLAY EAR TAG. ROLY DOESN'T GET TO BITE JOEY BACK.

MYRA OPENS UP TO HER HUSBAND, BYRON.

Sergey's Thursday Birthday Surprise!!!

"Mmm...socks."

It was no mystery to who gave Howie a hard thump to the head.

"Hmmm ahmm hmm hmm."

AN AWKWARD MOMENT OF SILENCE.

Shirley Furbloe gets caught up in an ugly rumor.

Jeff can relate to the wildlife.

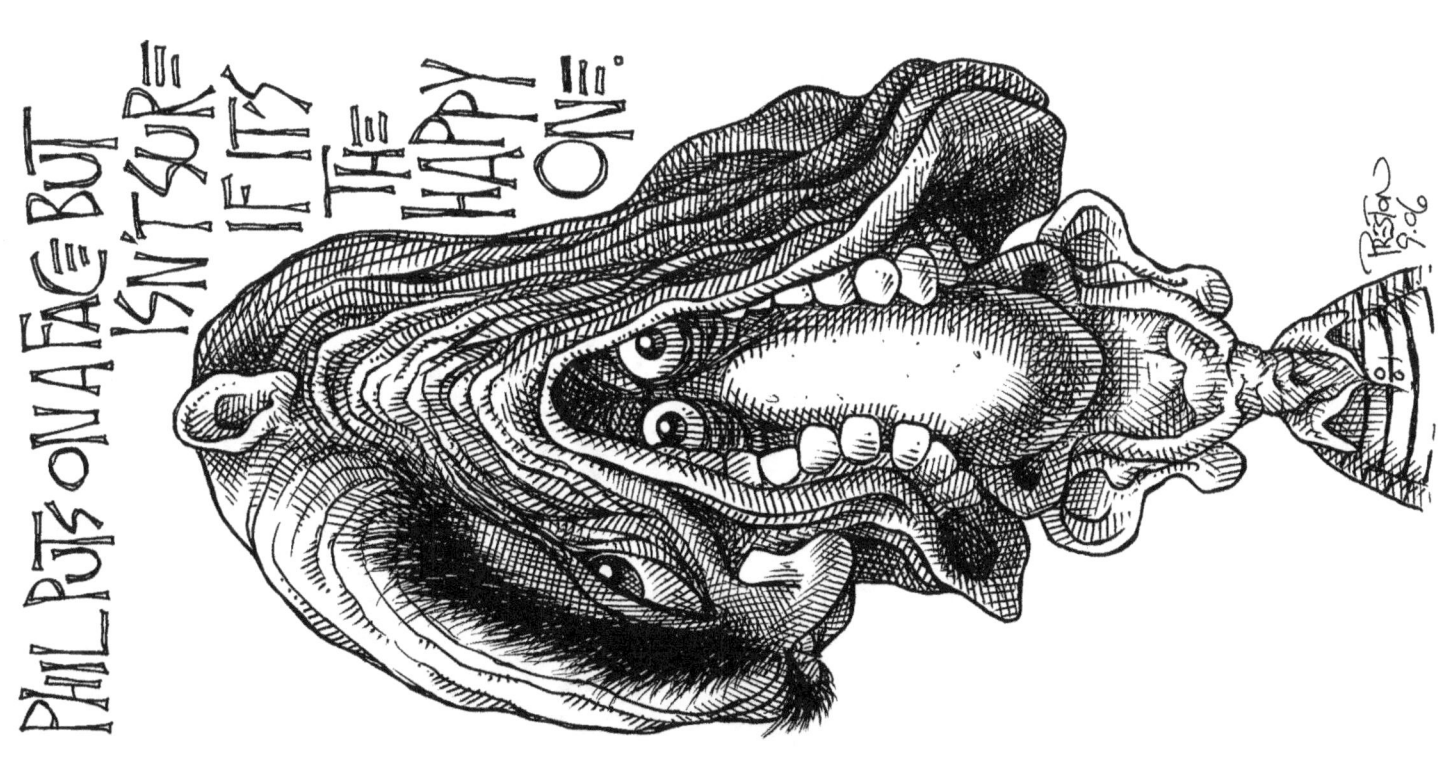

VALKE-MUR SAMSA — VAMPIROUS GLYPYGION

IT REALY BUGGED SAMUEL TO FIND STUFF IN HIS BOOK.

Clark's Rufwartle is known as "Hogmama" in the chatrooms.

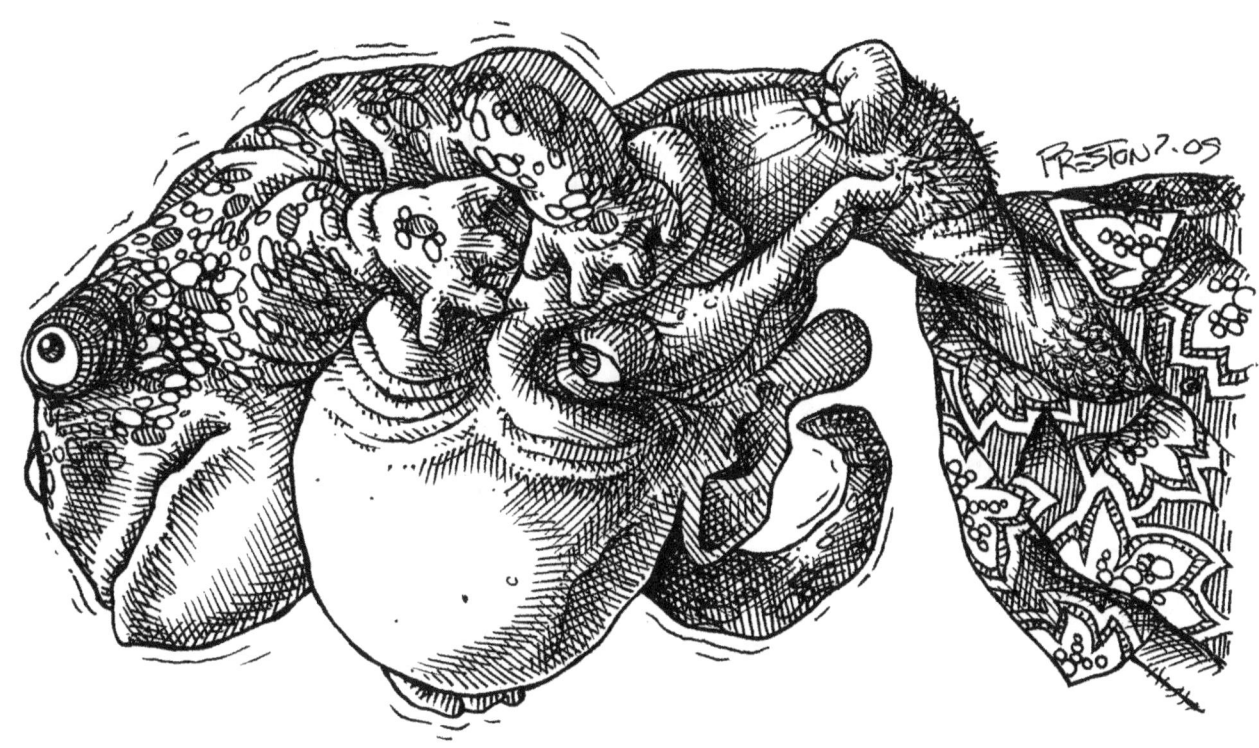

THUNDER! JAKE SCARED.

BRAD HEARS A DISTANT BARK AND FEELS THE NEED TO RESPOND.

THEN IT WAS AGAIN.

SICK!

Jock Feels Mocked.

SAMMY GOES TO THE MOVIES. FOLKS DON'T WANT HIM TO.

IF YOU STARE... MR. HUSS WILL GLARE!!!

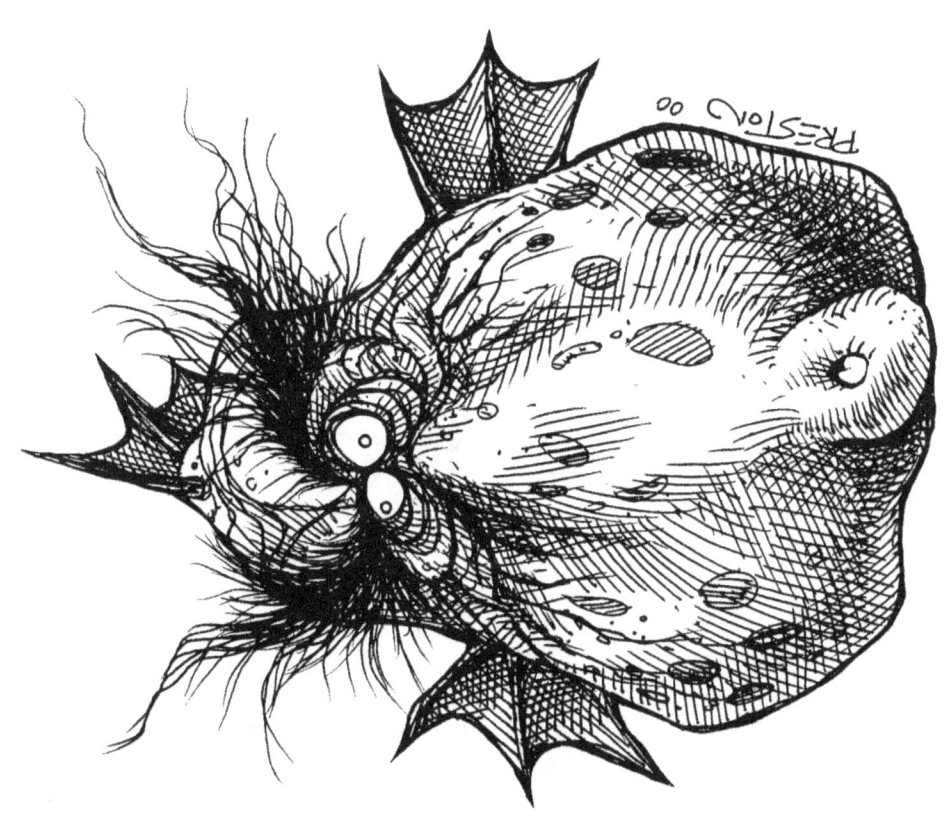